ART REVOLUTIONS
SURREALISM

Linda Bolton

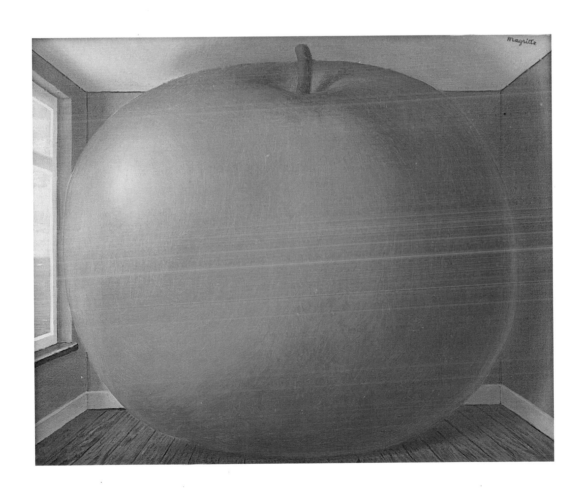

Belitha Press

First published in Great Britain in 2000 by

Belitha Press Limited
A member of **Chrysalis** Books plc
64 Brewery Road, London N7 9NT

Paperback edition first published in 2003

Editor Anna Claybourne
Series Editor Susie Brooks
Designer Helen James
Picture Researcher Diana Morris
Educational Consultant Hester Collicutt

ISBN 1 84138 109 8 (hb)
ISBN 1 84138 776 2 (pb)

British Library Cataloguing in Publication Data
for this book is available from the British Library.

Printed in China

Picture Credits:

front cover: Joan Miró, Harlequin's Carnival, 1924-5 © ADAGP Paris/DACS London 2000. Albright Knox Gallery, Buffalo, Photo Bridgeman Art Library. 1: René Magritte, The Listening Room, 1952 Kunsthaus Zürich, donated by Walter Haefner, Photo AKG London. 4: Hieronymus Bosch, The Garden of Earthly Delights, detail, 1505-10, Museo del Prado, Madrid. Photo AKG London. 5: Guiseppe Arcimboldo, Summer, 1563. Kunsthistorisches Museum, Vienna. Photo Bridgeman Art Library. 6: Giorgio de Chirico, The Song of Love, 1914. © SIAE Rome/DACS London 2000. The Museum of Modern Art, New York. Nelson A. Rockefeller Bequest. Photo © 1999 MOMA, NY. 7t: Marc Chagall, I and the Village, 1911. © ADAGP Paris/DACS London 2000. The Museum of Modern Art, New York. Mrs Simon Guggenheim Fund. Photo © 1999 MOMA, NY. 7b: René Magritte, The Red Model, 1935. © ADAGP Paris/ DACS London 2000. Musée National d'Art Moderne, Paris. Photo Peter Willi/ Bridgeman Art Library. 8: Salvador Dali, Slave Market with Disappearing Bust of Voltaire, 1940. © DEMART PRO ARTE, Paris & Geneva/DACS London 2000. Collection of The Salvador Dali Museum, St Petersburg, Florida. Photo © 1999 The Salvador Dali Museum Inc. 9t: Salvador Dali, Telephone-Homard, 1936. © DEMART PRO ARTE, Paris & Geneva/DACS London 2000. Photo Christie's Images/Superstock. 9b: Salvador Dali, Metamorphosis of Narcissus, 1937. © DEMART PRO ARTE, Paris & Geneva/DACS London 2000. The Tate Gallery, London. Photo John Webb/Tate Picture Library. 10: René Magritte, The Listening Room, 1958? Kunsthaus Zürich, donated by Walter Haefner. Photo AKG London. 11t: René Magritte, Euclidean Walks, 1955. © ADAGP Paris/DACS London 2000. The William Hood Dunwoody Fund. The Minneapolis Institute of Arts, Minnesota. Photo MIA. 12: Joan Miró, Person Throwing a Stone at a Bird, 1926. © ADAGP Paris/DACS London 2000. The Museum of Modern Art, New York. Purchase. Photo © 1999 MOMA, NY. 13t: Joan Miró, Harlequin's Carnival, 1924-5. © ADAGP Paris/DACS London 2000. Albright Knox Gallery, Buffalo. Photo Bridgeman Art Library. 13b: Joan Miró, Dog Barking at the Moon, 1926. © ADAGP Paris/DACS London 2000. Philadelphia Museum of Art, A.E. Gallatin Collection. Photo PMA. 14: Max Ernst, At the First Clear Word, 1923. © ADAGP Paris/DACS London 2000. Kunstsammlung Nordrhein-Westfalen, Dusseldorf. Photo Peter Willi/Bridgeman Art Library. 15: Max Ernst: Two Children Are Threatened by a Nightingale, 1924. © ADAGP Paris/DACS London. The Museum of Modern Art, New York. Purchase. Photo © 1999 MOMA, NY. 16: Paul Delvaux, Skeleton with a Shell, 1944. © SABAM Brussels/DACS London 2000. Private Collection. Photo © Foundation Paul Delvaux, St Idesbald. 17: Paul Delvaux, A Siren in Full Moonlight, 1949. © SABAM Brussels/DACS London 2000. Southampton City Art Gallery. Photo Bridgeman Art Library. 18: Yves Tanguy, Days of Delay, 1937. © ARS New York/DACS London 2000. Musée National d'Art Moderne, Paris. Photo Philippe Migeat, Photothèque des collections du Mnam-cci. 19: Yves Tanguy, Mama, Papa is Wounded, 1927. The Museum of Modern Art, New York. Purchase. Photo © 1999 MOMA, NY. 20: Man Ray, Cadeau (The Gift), c1958, replica of 1921 original. © ADAGP Paris/DACS London 2000. The Museum of Modern Art, New York. James Thrall Soby Fund. Photo © MOMA, NY. 21t: Man Ray, Les Larmes (Tears) 1932. © Man Ray Trust/ADAG Paris/DACS London 2000. Photo © Telimage, Paris - 1999. 21b: Man Ray, A l'Heure de l'Observatoire – les Amoreux, 1932–4. Private Collection. © Man Ray Trust/ADAGP Paris/DACS London 2000. Photo © Telimage, Paris 1999. 22: Francis Picabia, Feathers, 1921. © ADAGP Paris/DACS London 2000. Private Collection. Photo Giraudon. 23: Francis Picabia, The Handsome Pork-Butcher, 1924–6 & 29–35. © ADAGP Paris/DACS London 2000. The Tate Gallery, London. Photo Tate Picture Library. 24: Pierre Roy, A Naturalist's Study, 1928. © ADAGP Paris/DACS London 2000. The Tate Gallery, London. Photo Tate Picture Library. 25: Pierre Roy, Danger on the Stairs, 1927–8. © ADAGP Paris/DACS London 2000. Museum of Modern Art, New York. Gift of Abby Aldrich Rockefeller. Photo © MOMA, NY. 26: Roland Penrose, Winged Domino, Portrait of Valentine Penrose, 1937. © Estate of Sir Roland Penrose. Private Collection. 27: Roland Penrose, Seeing is Believing - The Invisible Isle, 1937. © Estate of Sir Roland Penrose. Private Collection. 28t: Meret Oppenheim, Lunch in Fur, 1936. © PRO LITERIS Zurich/DACS London 2000. Museum of Modern Art, New York. Purchase. Photo © MOMA, NY. 28b: Conroy Maddox, Passage de l'Opera, 1940. © the artist. The Tate Gallery, London. Photo Tate Picture Library. 29t: Leonora Carrington, Baby Giant, 1947. © ARS New York/DACS London 2000. Private Collection. Photo Bridgeman Art Library. 29b: Paul Nash, Harbour and Room, 1932-6. © The artist's estate. The Tate Gallery, London. Photo Tate Picture Library.

CONTENTS

Useful words are explained on page 30.
A timeline appears on page 31.

SURREALIST DREAMS

Can you paint something that's impossible? Could you draw what you see in your dreams? And can you see two different pictures in the same painting? The Surrealists did! They painted impossible objects, strange scenarios and bizarre optical illusions that amazed and thrilled the public. But why did they do it?

Surrealism began with a French poet called André Breton. It was soon after the First World War – which had lasted from 1914 to 1918 – and millions of people had been killed. Breton thought that art should move away from the horrible realities of war, politics and work.

Instead, he believed that dreams were the most important things in art – and in life. Rather than painting the real things they could see around them, Breton said artists should concentrate on their dreams, and paint whatever strange scenes and weird ideas their minds could create.

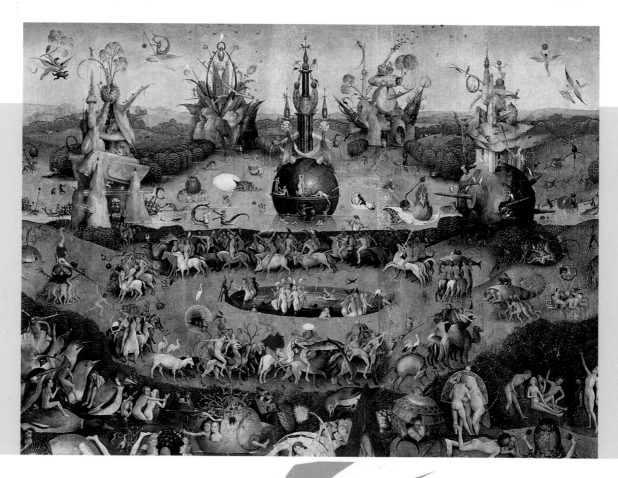

Breton and his friends took on the word surreal to describe their ideas. It means more than real. They used this word because they believed dreams weren't just different from real life – they were more real than real life! Breton said, 'Surrealism is based on the belief in the superior reality of the dream'.

He gathered together a group of poets and painters, who began to create Surrealist art. Some painted pictures of impossible things, like the things that happen in dreams. Others tried not to think about what they were writing or painting. They simply let the pencil or brush take a walk in their hand to see what would happen. Most of all, the Surrealists loved anything magical, unusual or surprising, such as people without faces, or strange combinations of objects.

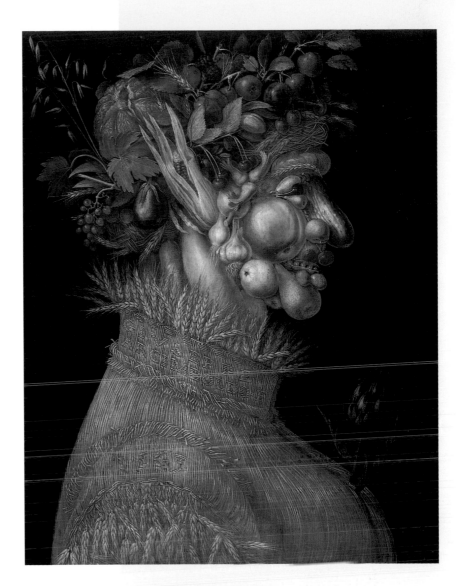

HIERONYMUS BOSCH
The Garden of Earthly Delights

(Detail) 1505–10, oil paint and tempera on panel

Although he lived 500 years ago, this Dutch artist was a very early Surrealist. Instead of painting what he saw around him, he conjured up wild, imaginary scenes of weird and fearful happenings. His works are nightmarish visions, full of giant birds, monstrous fish and people trapped in huge transparent bubbles. The Surrealists admired Bosch's unique style, and were amazed that he had created these strange pictures so long ago.

GIUSEPPE ARCIMBOLDO
Summer

1563, oil paint on canvas

The Surrealists also liked the work of Giuseppe Arcimboldo, a sixteenth-century Italian artist. He painted portraits made up of fruits and vegetables, such as this summery man. His nose is a courgette, his lips are cherries, his teeth are a pea pod, and his cheek is a peach! The Surrealists liked the way Arcimboldo used one object to represent another. They often made pictures that can be seen in two ways.

Besides dreams, the Surrealists were interested in madness, memory, chance and coincidence. They liked to put everyday objects in unexpected settings, and mix together very different ideas and images. For example, natural objects such as fruit and animals could be mixed with abstract shapes.

An object could start off looking like one thing, but appear to turn into something else half way down. To the Surrealists, it was this element of surprise that made art beautiful. They believed, as the poet Lautréamont said, that 'beauty should seize you by the throat'.

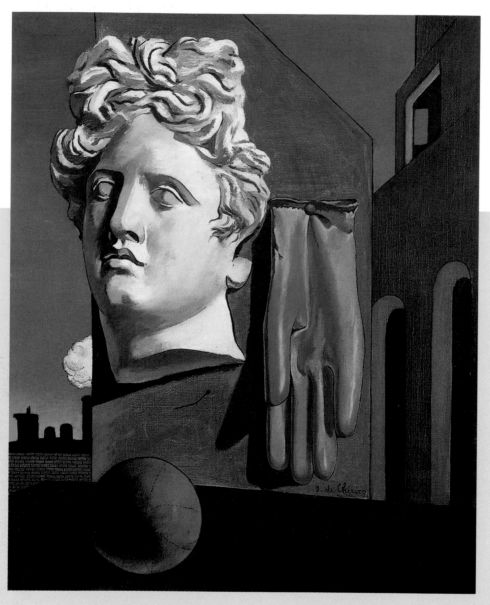

GIORGIO DE CHIRICO
The Song of Love

1914, oil paint on canvas

The Surrealists were strongly influenced by the Italian painter Giorgio de Chirico. This picture was painted just before the Surrealist movement began, but, like Surrealist art, it's full of surprises and seems to make no sense. For a start, the title – *The Song of Love* – seems to have nothing to do with what's in the painting. Instead of lovers, we see a strange mixture of objects: a large rubber glove, a statue of a head and a green ball. And what is the shape on the left? Is it a train funnel blowing a puff of steam, or are we looking at a white cloud in the blue sky? The Surrealists admired this puzzling style and used it in their work.

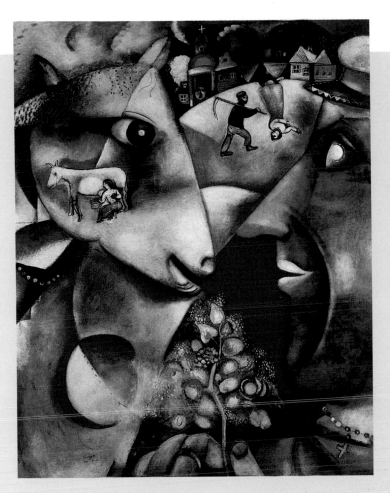

MARC CHAGALL
Me and the Village

1911, oil paint on canvas

Chagall was a Russian painter who lived in Paris. This picture, *Me and the Village*, shows Chagall's home town of Vitebsk in Russia. As you can see, it isn't a realistic scene. A woman walks upside down in the sky, the large human face is green with white lips, and the sheep wears a string of beads. The houses and church of the village are multicoloured and some of them are upside down as well. It's like a kaleidoscope of dreams and memories, thrown together and shaken. Many Surrealists were inspired by Chagall. They often painted memories, and made objects and people defy gravity.

RENÉ MAGRITTE
Red Model

1935, oil paint on canvas

The title of this painting – *Red Model* – alerts us to the strangeness of the image we're looking at. There is nothing red in this painting, and there's no model either – unless it's the two strange-looking objects in the foreground. Are they boots or feet? Could you put them on? And how have they reached this piece of rough ground by a fence? Did they walk there? The painting seems to delight in being as odd and confusing as possible, even though it's made up of familiar things.

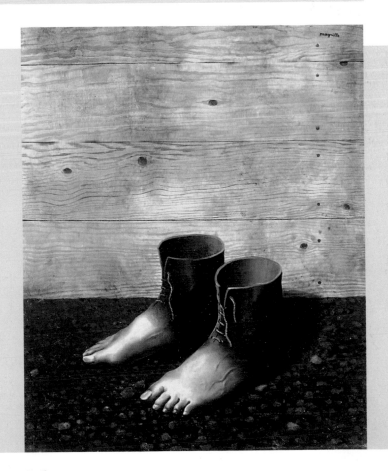

SALVADOR DALI 1904–1989

'The difference between a madman and me is that I am not mad.'

The Spanish painter Salvador Dali joined the Surrealists in 1928, after he moved to Paris from Spain and met André Breton. He is the most famous Surrealist – even though Breton threw him out of the Surrealist movement for being too interested in making money!

Dali's paintings are often highly detailed, and show weird, distorted figures and objects in impossible landscapes. He claimed that many of them were accurate pictures of his own dreams. Dali's lifestyle was also quite surreal. He built a bizarre house and grew a long, curly moustache.

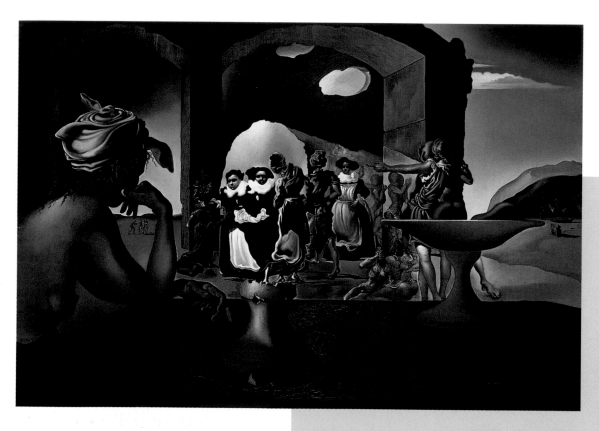

Slave Market with Disappearing Bust of Voltaire

1940, oil paint on canvas

Dali was fascinated by the idea of seeing two different pictures in one painting. In the middle of this painting you can see either small figures in a marketplace, wearing black clothes, or a large bust of a bald French philosopher called Voltaire. But can you see them both at once? It's very difficult – the images are both there, but you can only focus on one or the other. Dali gave this way of painting a fancy title. He called it the 'paranoid-critical' method.

Lobster Telephone

1936, plastic, plaster and mixed media

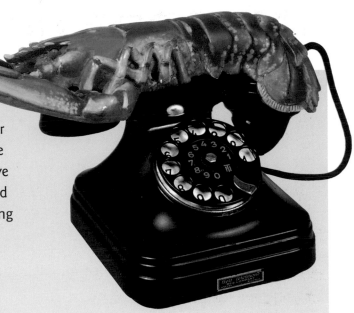

Dali has replaced the handset of this phone with a big model lobster. In a strange way the lobster is similar to a real handset, with its sausage-shaped body and the curl of its tail. But at the same time it's the last thing we expect to see on top of a telephone! It's both funny and frightening to imagine picking up the lobster and holding it to your ear. Dali's combination of two very different objects – one natural, one mechanical – is typical of the Surrealist way of attracting our attention.

Metamorphosis of Narcissus

1937, oil paint on canvas

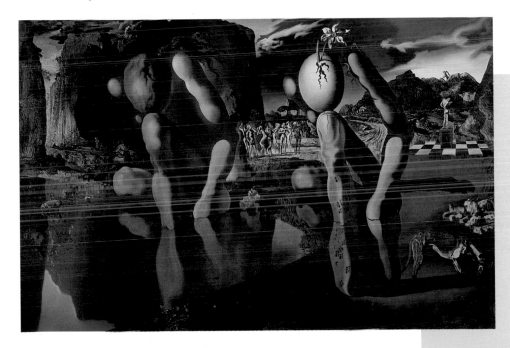

In Greek myth, Narcissus was a beautiful boy who looked into a pool, fell in love with his own reflection and died of longing. On the spot where he died a flower grew, and it was named after him. Dali's modern version of the story shows not only Narcissus and his reflection, but also a strange stone hand holding an egg, with the narcissus flower bursting out of it. This exactly repeats the shape of the crouching figure of Narcissus. And can you see the same shape a third time in the background?

DOUBLE TAKE

Dali's paranoid-critical pictures show two things at once. To create this effect, try drawing the outlines of two identical faces in profile, facing each other. Draw them so that the shape left in between looks like an ornate vase.

RENÉ MAGRITTE 1898–1967

'The only thing that engages me is the mystery of the world.'

Magritte was a Belgian artist. He met the Surrealists when he spent three years in Paris, from 1927 to 1930. His strange, puzzling paintings may remind you of dreams – even nightmares. Yet they are also very clear and beautiful, with calm, simple colours and shapes.

Magritte had several favourite subjects which appear again and again in his work – such as steam trains and men in bowler hats. He often used words in his paintings, and made familiar objects seem strange by changing their scale or making them break the laws of science.

The Listening Room

1952, oil paint on canvas

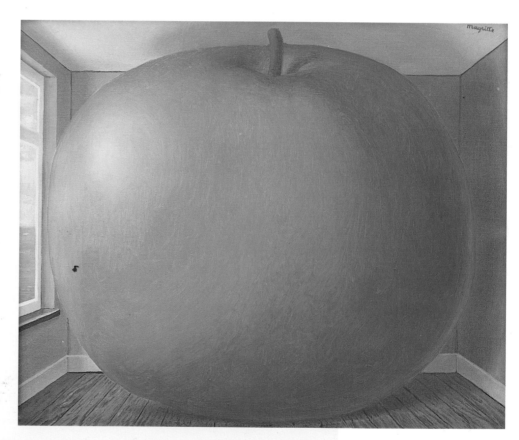

This giant apple fills an otherwise empty room, like something from *Alice in Wonderland*. In a way the fruit's immense presence is threatening – but we can also feel the apple's panic or claustrophobia at the lack of space around it. Magritte's title, *The Listening Room*, makes you think about the atmosphere in the room. Who is meant to be listening – the apple, the room, or the person looking at the picture? And what are they listening to? Magritte plays with words and objects in his paintings, using a few simple elements to make powerful, striking images.

Not to be Reproduced

1937, oil paint on canvas

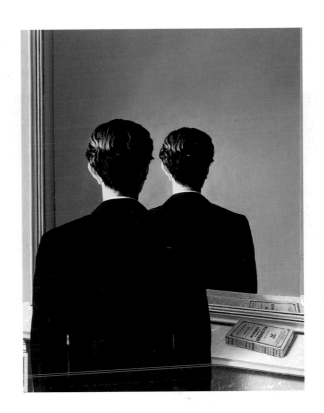

Magritte gave this spooky painting a clever title. 'Not to be reproduced' is a phrase often used by artists who don't want their work to be copied. At the same time it makes you think about what's going on in the painting. The mirror we see here doesn't reflect the man's face as you'd expect. Instead, it 'reproduces' his back – yet it reflects the book on the shelf normally! Although we can't see his face, this is a portrait of Edward James, an English collector of Surrealist objects. He owned Dali's famous *Lobster Telephone* (page 9) and Magritte's *Red Model* (page 7).

MAKE A MAGRITTE

To create a Surrealist artwork, paint two very different objects (or cut them out of magazines). Put them in a setting where you would never see them in real life. Then give your picture a title that has nothing to do with anything in it!

Euclidean Walks

1955, oil paint on canvas

Many of Magritte's works are paintings of other paintings. Here we can see a picture resting on an easel in front of a window. Whoever painted it has copied the scene outside so perfectly that it's hard to tell where the canvas ends. Magritte has also tried to confuse us by repeating one shape twice within the painting. There are two cones, identical in size, but they seem to be different things. One is a spire on top of a tower, the other looks like a road disappearing into the distance. Perhaps the title gives us a clue. Euclid was the inventor of geometry, the science of shapes.

JOAN MIRÓ 1893–1983

'The most Surrealist of us all.'

Like Dali, Miró was born in Spain but spent most of his working life in Paris. He was often reduced to poverty, and sometimes had hardly anything to eat. Miró said that hunger made him hallucinate. He saw vivid, colourful visions which weren't really there, and copied them in his work.

Like other Surrealists, Miró was also fascinated by childhood. The Surrealists believed that children had pure emotions, unspoilt by adult worries. Miró wanted to be like a child when he painted. He tried to free his unconscious mind and let his emotions and imagination take over.

Person Throwing a Stone at a Bird

1926, oil paint on canvas

You can see Miró's childlike style in this colourful scene, with its yellow sand, black sea and green sky. There's an odd-looking figure with a giant foot and a single eye – the title tells us it's a person. Miró's bird is made of bright geometric shapes, while the stone's flight is marked with a dotted line. Strangest of all, the stone-thrower seems to have no arms – unless they're represented by the thin black line.

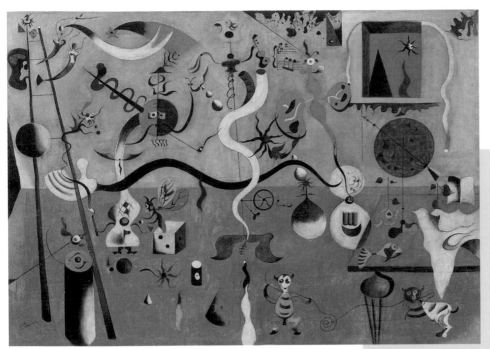

The Harlequin's Carnival

1924–5, oil paint on canvas

Inside this room a party of energetic shapes cavort and play. The musical stave on the wall suggests the room is full of lively sounds to which these figures are dancing. They seem to be bouncing on coils, jumping from the ladder and swimming through the air. The night sky, seen through the window on the right, looks peaceful compared with the pandemonium inside. Is this what Miró's brain conjured up when he'd had no lunch?

MIND GAMES

Miró often tried to paint without thinking about it. Try closing your eyes and letting your pencil wander over a piece of paper. Fill in the patterns with bright paint. Then ask a friend to give your artwork a title.

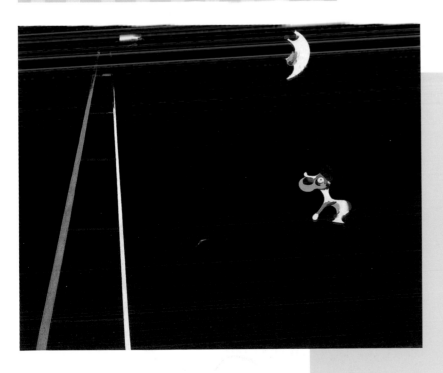

Dog Barking at the Moon

1926, oil paint on canvas

The dog and the moon in this painting look a bit like cartoons – they are distorted and colourful. At the same time, the dark sky and the ladder reaching into the nothingness make the picture quite sad. Miró's father died the year this image was painted. Could the ladder reaching upwards be something to do with that? Like many of Miró's pictures, this one was given its title by his friends, after it was finished.

MAX ERNST 1891–1976

'I saw myself falling in love with what I saw.'

Max Ernst was German but, like many of the Surrealists, he met André Breton in Paris. Breton told Ernst not to think about his art, but to start with something accidental. This happened naturally one rainy day when Ernst was staying at an inn by the sea, and began to stare at the floor.

Hypnotised by what he saw, Ernst started to make rubbings of the floorboards. Moving the paper at random, he created images of strange visions and other worlds. He also experimented by rubbing paper on tree bark, drawing with candle smoke, and smudging blobs of paint.

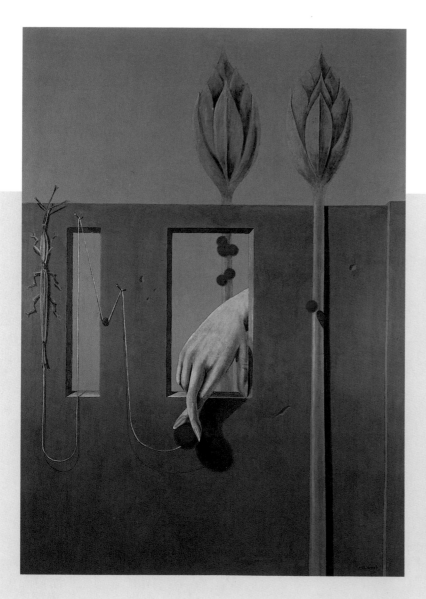

At the First Clear Word

1923, oil paint on plaster, transferred to canvas

As well as his strange experimental art, Ernst followed the Surrealist tradition of painting clear, bright pictures of puzzling scenes. In this one, a hand pokes through a window-like hole to grasp a ball which dangles from a piece of string. The simple mathematical shapes are combined with natural elements – two plants and a green insect. But however hard you try, it's impossible to link what's in the painting with its strange title. And are the crossed fingers to do with hoping, or lying? We will never find an answer, because Ernst has deliberately made this an illogical painting. He provides the images. We are to interpret them as we choose.

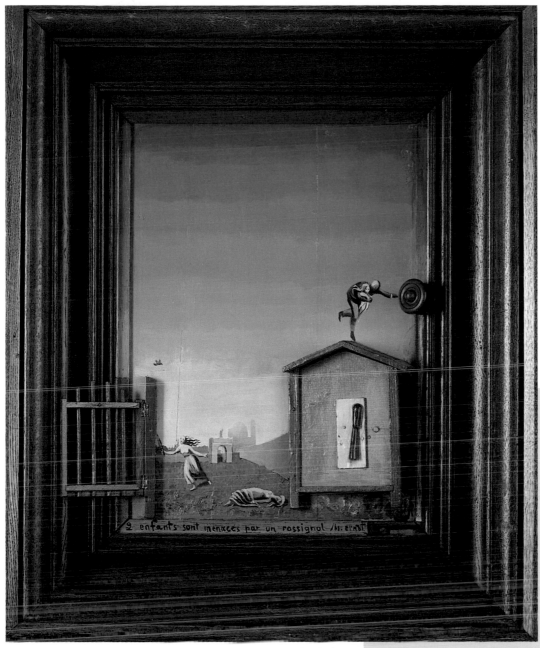

2 enfants sont menacés par un rossignol /M. ernst

Two Children are Menaced by a Nightingale

1924, oil paint on canvas with wood

RANDOM RUBBINGS

Copy Ernst's methods by taking rubbings from floorboards, tree bark and other textured surfaces. Hold the paper still and rub a wax crayon or a soft pencil over it. What do the marks remind you of?

The nightingale is known for its sweet singing, not for scaring children! And there are more than two figures here – one girl is running, a second lies on the grass, and a third is held by a man on the roof. The tiny nightingale flutters quietly on the left of the picture.

Ernst has written the mysterious title of this painting on the frame. And some parts of the picture – the gate and the strange red buzzer high on the right – are built in wood and stuck to the frame. It's as if they offer an escape out of the painting and into a different, 3D world. Ernst's picture makes us think of being trapped in a strange hallucination, or even a nightmare.

PAUL DELVAUX

1897–1994

> *'I thought only of trying to express something which was quite indefinable.'*

Delvaux was born in Belgium and, unlike some of the Surrealists, trained as a painter from an early age. He was inspired by the work of de Chirico, whom he called 'the poet of emptiness'. Delvaux wanted to create the same kind of art.

He admired de Chirico's simple, empty style and his use of shadows. His paintings also use many images copied from de Chirico, such as Greek temples and steam trains. Delvaux remained a Surrealist painter throughout his very long life.

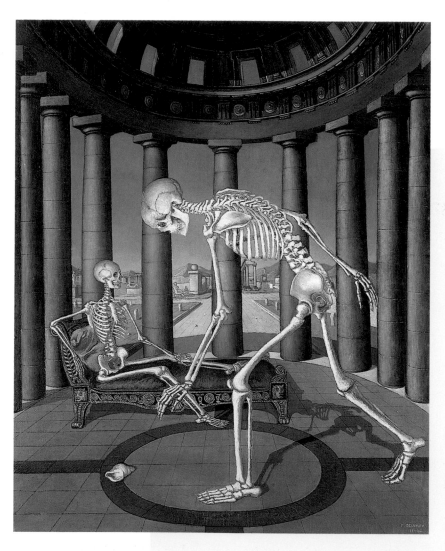

A Skeleton with Shell

1944, oil paint on masonite

Delvaux often used classical scenes in his paintings. Here, two skeletons are inside what seems to be a Greek temple, with a ring of tall stone pillars around them and an ornate dome above their heads. The strangeness of this picture comes partly from the fact that instead of lying dead among ancient ruins, the skeletons are behaving like living people. While one is stooping to pick up a shell from the tiled floor, the other is reclining on an elaborate chaise longue. The living bones, combined with a mixture of ancient and modern objects, suggest that several different time periods have come together in one moment.

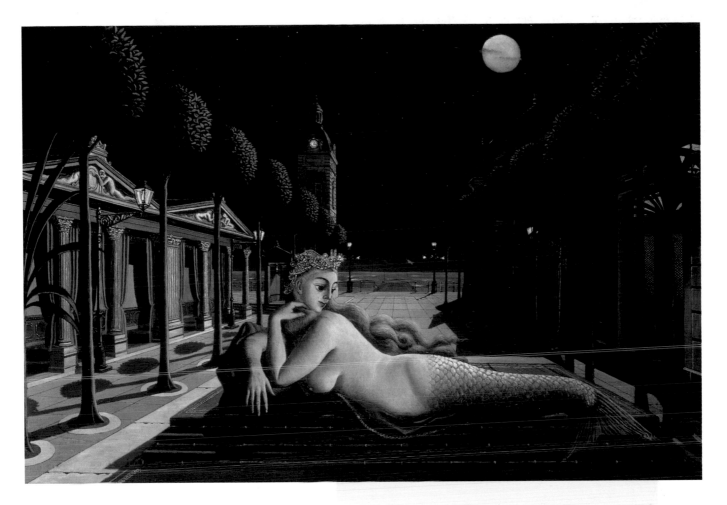

A Mermaid in Full Moonlight

1949, oil paint on wood

DREAM VISIONS

The strange, impossible scenes in many Surrealist paintings come from the world of dreams. Try to remember one of your dreams and write it down as soon as you wake up. Then paint what happened in your dream as clearly as you can.

It's clear as soon as you look at this painting that something is out of place. A mermaid belongs in the sea – how did she reach this cold, deserted classical square? The fact that she is on a plinth suggests she might be a statue – but she seems to be very much alive. As in so many Surrealist pictures, something natural – or in this case supernatural – is combined with the geometric shapes and lines of buildings and machines. Look at the time on the clock tower – a quarter past twelve. It's the witching hour – the hour between midnight and one o'clock. According to fairy tales, this is when humans sleep and dream, mythical creatures inhabit the world, and the everyday is turned into the magical and strange. Perhaps, by the break of day, the mermaid will have turned to stone.

YVES TANGUY 1900–1955

'Painter of subterranean and oceanic marvels.'

Yves Tanguy (pronounced 'tong-ee') was born in Paris, and had several jobs. As a merchant seaman, he went to South America and Africa. He also worked in a press cuttings agency, as a tram driver, and as a toasted-sandwich maker. Then, one day, from a bus, he saw a painting by Giorgio de Chirico, and began to paint.

After meeting André Breton, who became a close friend, Tanguy joined the Surrealists. His paintings do not show recognizable objects or scenes. Instead they are full of strange jelloid shapes, crawling on moon-like surfaces. This may reflect Tanguy's fascination with the curious rock formations he saw during a trip to Africa.

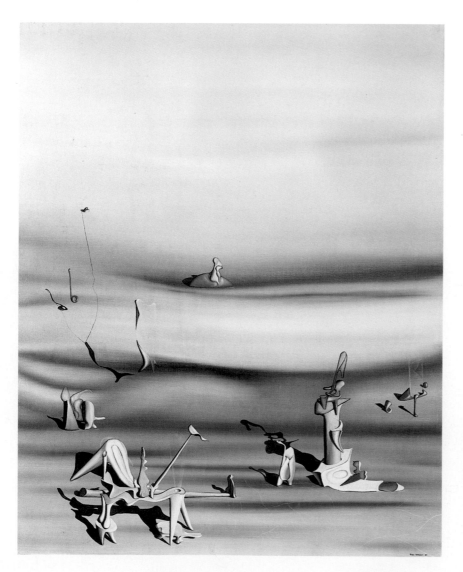

Days of Delay
1937, oil paint on canvas

The title *Days of Delay* adds to the strangeness of this painting, in which unfamiliar shapes seem to crawl across a smooth, empty landscape. Is that the sky we can see at the top, or does the land sweep upwards to fill the whole painting? Where is this place? It could be the desert, the moon or another planet. It's impossible to tell – but although this looks like a space-age vision, it could not have been based on a real moon-scape. It was created long before the first moon landing in 1969.

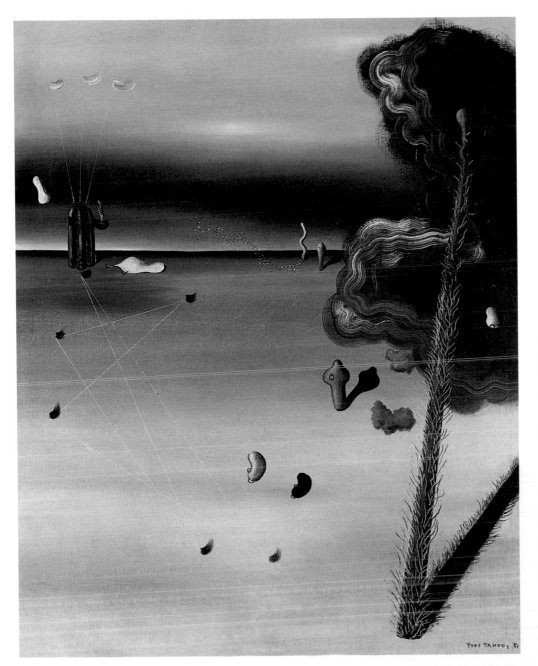

Mama, Papa is Wounded!

1927, oil paint
on canvas

The alarming title of
this painting makes
us expect an active
or even tragic scene.
But when you look
for injured people
or dangerous objects,
all you can see are
strange scattered
shapes. What is the prickly stem on the right?
What is behind it? And what are the white
lines joining the objects on the left? Tanguy
does not give anything away. He has let his
unconscious mind produce a picture which
the viewer can only puzzle over. Looking at
Tanguy's pictures is a bit like waking up from
a disturbing dream. You struggle to work out
the meaning of the things you have seen –
but perhaps they have no meaning at all.

OUT IN SPACE

Tanguy's paintings look like other
worlds, with unfamiliar landscapes
and unknown creatures. How would
you create your own extraterrestrial
landscape? What would the creatures
who lived there look like?

MAN RAY
1890–1976

'Nothing is really useless.'

Man Ray was an American photographer who became part of the Surrealist movement in Paris. He used many different materials, or media, in his art. He produced Surrealist paintings and objects, but is most famous for his photographs.

Ray believed that photography was an art. He created carefully-posed portraits, often containing objects as well as people. He also invented Rayographs – abstract pictures made by placing objects on light-sensitive photographic paper.

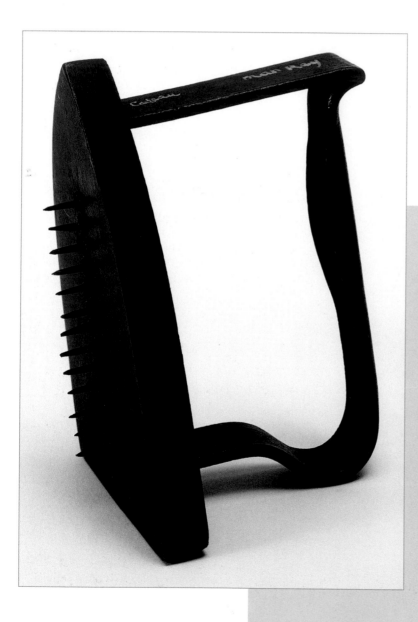

The Gift

1958 (replica of original of 1921), painted flatiron and tacks

Man Ray made this sculpture by sticking a row of sharp tacks on to a household iron. Instead of being a helpful domestic device, the iron is now useless – even dangerous. Just looking at it makes you think of what would happen if you tried to iron something with it. And the title makes things even worse – what would you think if someone gave this to you as a gift? The simple combination of two everyday household things – with two very different uses – creates something that is funny, shocking and unnerving all at the same time. Artworks that use manufactured objects in this way are sometimes known as ready-mades.

Glass Tears

1930–33, silver print

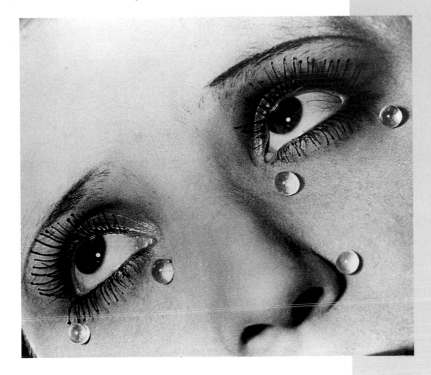

This is one of Man Ray's most famous photos. It shows part of a woman's face in close-up. We can see quite clearly the round, shiny glass tears stuck on to her cheeks, and her long, bobble-ended false eyelashes. Her stage make-up and exaggerated expression make her look like a film star in a silent movie. This is not a convincing picture of a woman crying. Instead, Man Ray has focused on the perfect forms of the artificial tears and lashes and wide oval eyes. The shapes almost look like parts of an abstract painting.

PECULIAR PORTRAIT

You could create a Surrealist portrait by asking a friend to pose for a photo with an object replacing one of their features – try covering a cheek with a flower, for example, or placing an egg over one eye (they can lie down so that it doesn't fall off!). Take the photo as close-up as possible. Does your portrait change the person's image?

Observatory Time

1932–34, oil paint on canvas

Man Ray wrote the following words about this surreal image: 'The red lips floated in a bluish sky over a twilit landscape, with an observatory... dimly indicated on the horizon.' He said the lips were so large that they looked like two bodies – 'like the earth and sky, like you and me'. Man Ray makes the scene sound peaceful, but it is also scary and strange, with the huge pair of lips hovering like a menacing UFO.

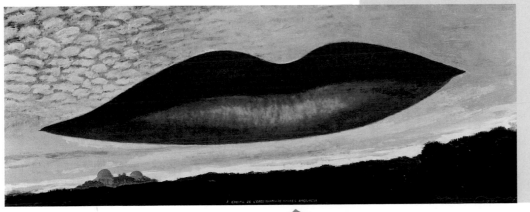

FRANCIS PICABIA 1878–1953

'The paintings that I make are very much in rapport with my life.'

Picabia was born in Paris, and created many different types of art during his life. He worked as a Cubist with artists such as Picasso, and then became part of a group called the Dadaists. Dada was a zany art movement which developed in Switzerland and spread to Europe and America.

The Dadaists created deliberately child-like paintings. They liked unplanned art and nonsense images. The movement ended in 1922, but the Surrealists adopted many of the same ideas, and Picabia joined them. He was famous for his cover designs for *Littérature*, a Surrealist magazine.

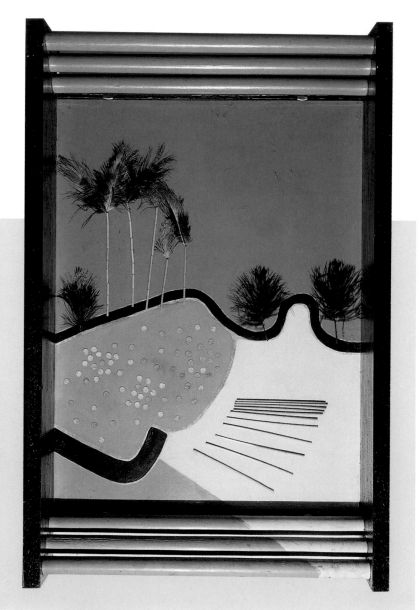

Feathers
1921, oil paint and collage

Here Picabia has used feathers, pasta and paper – the kinds of things children might use in their collages – to create a picture of a beach. The feathers represent palm fronds, the sticks of pasta look like steps up a sand dune, and the beach pebbles are made of corn plasters! Instead of a canvas, Picabia has used what looks like a wooden tray. The picture is very simple, but the collage method allows images such as the feathers/ palm fronds to be two things at once – as in the work of other Surrealists such as Dali (see pages 8–9).

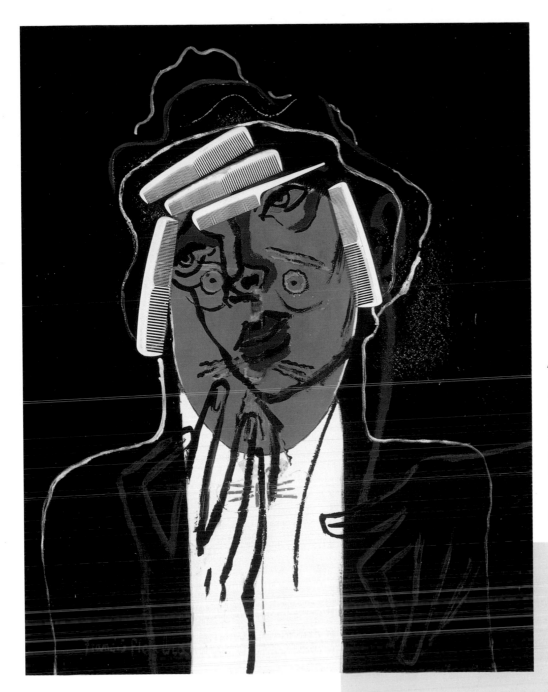

The Handsome Pork Butcher

1935, oil paint on canvas

Picabia painted this strange portrait on top of another of his works – a collage which he'd completed a few years earlier. You can see the shapes of a man's eyes and moustache, his pink face and his hair made out of real plastic combs. But on top of this Picabia has painted what looks like the outline of a beautiful woman's face. The lines on the man's white shirt look at first glance like stains– perhaps from his butcher's shop – but they can also be seen as the beautiful woman's hand. The picture seems to be showing two different people at once. Do you think it's a handsome portrait?

BITS AND PIECES

Make a collage using some of the materials you used when you were younger – pasta shapes, ring pulls and bottle tops, string and silver foil. What do they really remind you of? Create a landscape or a portrait – or whatever your materials suggest.

PIERRE ROY 1880–1950

'Surprises in daylight.'

Pierre Roy began his career working in an architect's office, but joined the Surrealist movement after meeting Giorgio de Chirico (see page 6) in Paris. He was greatly impressed by de Chirico, whom he called the father of Surrealism.

Roy's own pictures, like those of de Chirico and Magritte, look realistic but combine unlikely objects to produce unreal and dream-like scenes. Roy claimed he often worked out the meanings of his paintings months after they were finished.

A Naturalist's Study

1928, oil paint on canvas

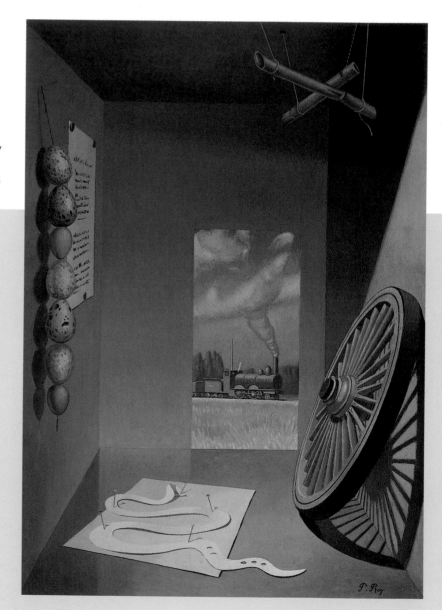

Roy often painted snakes, and in this picture a snake-like shape seems to be pinned to the floor. This snake and the string of eggs hanging on the wall might belong to a naturalist – someone who studies nature and wildlife. But what about the wheel and the train? As in many Surrealist works, natural and mechanical images are mixed together. And, like Magritte and Dali, Roy plays with double possibilities. Are we looking at the train through a window, or is it part of a picture on the wall? And at what point do the puffs of steam from the train turn into clouds? We're left to puzzle.

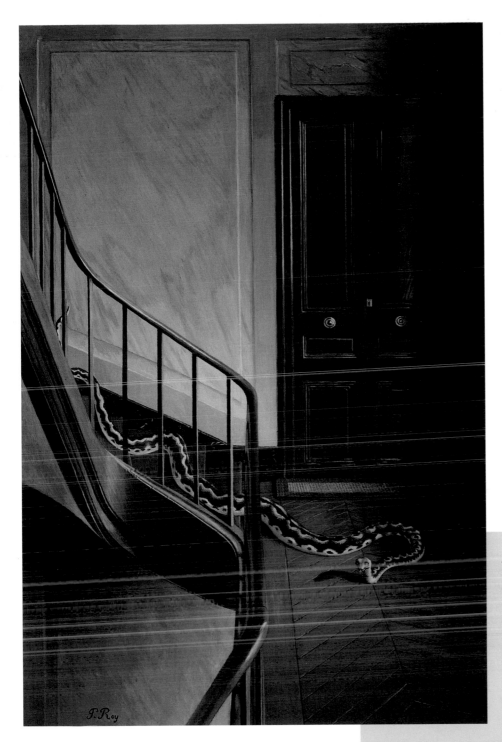

Danger on the Stairs

1927–8, oil paint on canvas

The danger on the stairs is quite clear here. This snake is especially scary because it is not in the surroundings we might expect – a zoo or the jungle. Instead it is making its way downstairs, past the closed doors of a respectable Paris apartment and along the polished passageway. Roy plays on our fears by bringing something dangerous and wild into a safe, everyday setting. Yet at the same time, these two opposed elements have something in common – the snake's writhing form is echoed in the twisting spiral of the staircase and bannisters.

SCARY SIGHTS
Roy's pictures of snakes represent things that we fear turning up in the midst of everyday life. What are you most afraid of? Spiders, heights, or enclosed spaces? Try painting the thing that scares you.

ROLAND PENROSE
1900–1984

'Writing tomorrow's news in the sky.'

Roland Penrose was born in London and went to Paris after the First World War to study art. He was introduced to Surrealism by Max Ernst (see pages 14-15) and they became great friends. Later, Penrose introduced Surrealism to Britain.

As well as being a painter and sculptor, Penrose used his money to promote art and fund artists. He organized a big Surrealist exhibition in London in 1936, and wrote several books, including one about the great twentieth-century artist Picasso.

Winged Domino – Portrait of Valentine

1937, oil paint on canvas

The second part of the title says this is a portrait, perhaps of a real person. But something else is going on here too. The very features which help us recognize a person are covered up in this portrait by butterflies. A domino is a type of mask, and although she doesn't seem to be wearing a mask, Valentine's blue skin makes her look strange and unnatural. With her calm, cold stillness, her thorny necklace, and the bird on her shoulder, she looks like a statue that has been overrun by wildlife.

Seeing is Believing – The Invisible Isle

1937, oil paint on canvas

The isle of this painting's title is formed where a cascade of hair meets an array of building-like shapes and a hand rising out of a shining sea. There's not much natural landscape to be seen, but the image of an island is created from the other elements. Is the upside-down head hanging from the stormy sky – or is it rising up as a craggy mountain with a face carved into it? Try looking at this painting the other way up. It works just as well as Surrealist art when viewed upside-down.

HEAD CASE

In both these pictures Penrose does strange things to an image of a woman's head. You could cut a similar head out of a magazine and make it into a house or a mountain – or stick other images such as insects and fruit over its features.

MORE SURREALISM

The Surrealist movement inspired dozens of artists to try its methods and media. These are just a few of the artworks they created.

You can see several of the themes mentioned in this book on these two pages – such as men in bowler hats and things that seem out of place.

MERET OPPENHEIM
Breakfast in Fur

1936, fur-covered cup, saucer and spoon

Meret Oppenheim was a Berlin-born painter and object-maker. Her fur-covered cup and saucer has become one of the most memorable Surrealist images.

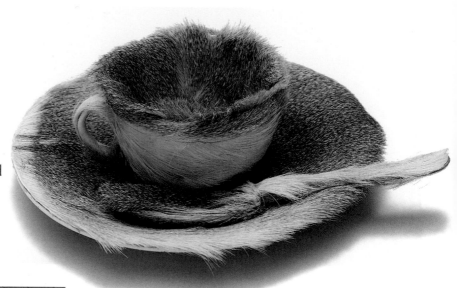

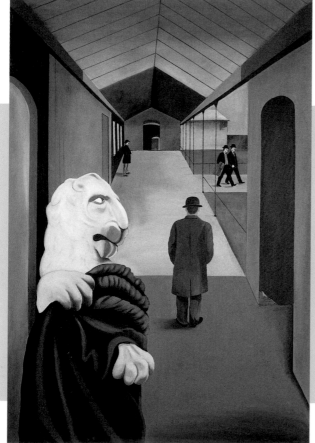

CONROY MADDOX
Passage de l'Opéra

1940, oil paint on canvas

The work of this English Surrealist artist looks similar to that of René Magritte (see pages 10–11). Neat-looking men in coats and bowler hats stroll along, but the startling lion in the foreground makes this scene far from normal. Its whiteness makes it look like a statue – but its cloak and alert face make it seem frighteningly alive.

LEONORA CARRINGTON
Baby Giant

1947, oil paint on canvas

Leonora Carrington was born in England but moved to Mexico. In this picture the baby giant, holding an egg, towers over two worlds – a seascape with whales and Viking ships, and a woodland with magical creatures. Eggs appear in many of Carrington's paintings.

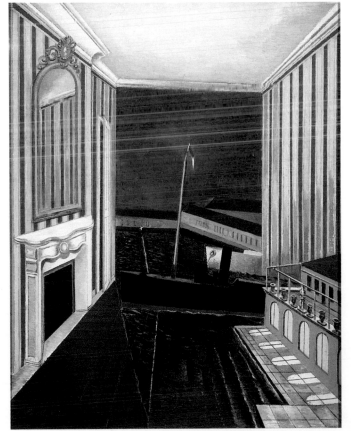

PAUL NASH
Harbour and Room

1932–6, oil paint on canvas

Nash was another English Surrealist whose work resembles that of Magritte and Delvaux. The scene in this painting is both the inside of a room, and, on a completely different scale, a port. Water comes into the room and washes across the tiled floor at an angle.

abstract art Art that does not show images that we can easily recognize.

bust A statue of a head and shoulders.

canvas A strong fabric which artists paint on.

classical A word used to describe anything to do with the ancient Greeks and Romans.

claustrophobia (pronounced klos-tra-*foe*-bee-ya) A fear of being enclosed in a small space.

collage A collection of materials, such as paper, fabric and photos, stuck on to a background.

Cubism An art movement in which artists made paintings and collages using geometric shapes such as cubes, cylinders and cones.

geometry The part of maths that deals with lines, shapes and surfaces. Many Surrealist pictures include geometric images such as spheres, curves and dotted lines.

hallucination An image of something that isn't really there, but is produced by your brain. Drugs can make people hallucinate, and so can being very hungry, tired or unwell.

image A picture or idea.

masonite A kind of tough board made from wood fibre, used by some artists for painting on.

media The types of paint and materials an artist uses to make a work of art.

metamorphosis A complete change from one thing into another.

movement A style or period of art, usually created when a group of artists get together.

optical illusion A picture that plays tricks on your eyes and brain – such as Dali's paranoid-critical paintings.

paranoid-critical method A phrase invented by Dali to describe pictures that can be seen in two completely different ways.

plinth The base that a statue rests on.

reality The real things that surround us, such as houses and people, as opposed to what we see in dreams and in our imagination.

replica An exact copy of something.

surreal More than real, or 'on top of' real. This word is made up of *sur* (the French word for on) and the word real.

tempera An old-fashioned paint made of coloured powder mixed with egg white.

unconscious A part of your mind that you don't use for thinking. You are not aware of your unconscious mind, but it can have an effect on your dreams and fears. In their work, the Surrealists tried to let their unconscious minds take over from rational thought.

vision Something that we can see in our imagination or in a hallucination.

SURREALIST TIMES

1900 Dr Sigmund Freud publishes *The Interpretation of Dreams*, a book about the unconscious mind which influences Surrealism.

1921 Breton visits Freud in Vienna.

1924 Breton publishes first *Surrealist Manifesto*, explaining the rules of Surrealism.

1925 First Surrealist exhibition takes place in Gallerie Pierre, Paris.

1926 Man Ray makes Surrealist film, *Emak Bakia*. Belgian Surrealist group is started.

1928 Breton publishes book *Surrealism and Painting*. Dali and his friend Luis Buñuel make a Surrealist film, *Un Chien Andalou*.

1930 Breton publishes second *Surrealist Manifesto*. Magazine called *Surrealism in the Service of the Revolution* is started.

1933 Glossy Surrealist magazine *Minotaur* is started.

1934 Surrealism takes off in Egypt.

1935 International Surrealist exhibition is shown in Copenhagen and Tenerife. First *International Bulletin of Surrealism* is published in Prague.

1936 An exhibition of Surrealist objects takes place at Gallerie Ratton, Paris. An international Surrealist exhibition is shown in London.

1938 Another international Surrealist exhibition takes place in Amsterdam.

FURTHER INFORMATION

Museums to visit

Surrealist art can be seen in museums and art galleries all over the world. Some of the biggest collections are in America, including the **Salvador Dali Museum**, St Petersburg, Florida, and the **Museum of Modern Art**, New York.

In Europe you can visit the **Dali Museum**, Figueras, Spain and the **Fundacio Joan Miró**, Palma, Majorca, Balearic Islands, Spain. The **Musée Royaux des Beaux-Arts**, Brussels (for Magritte and Delvaux) and the **Paul Delvaux Museum**, Saint Idesbalt, are two collections in Belgium.

In the UK, the **Tate Modern**, London, and the **Brighton Art Museum**, both house many interesting examples of Surrealist art.

Websites to browse

http://www.surrealist.com/index.html
http://www.duke.edu/web//lit132/index.html
http://www.surrealism.co.uk

Books to Read

Dali's Mustache by Salvador Dali and Philippe Halsman, Flammarian, 1994

Hello Fruit Face! The Pictures of Guiseppe Arcimboldo by Claudia Strand, from the *Adventures in Art* series, Prestel, 1999

Mark Chagall: Life is a Dream by Brigitta Höppler, from the *Adventures in Art* series, Prestel, 1998

Miró in his Studio by Joan Punyet Miró, Thames & Hudson, 1996

Now You See It – Now You Don't: René Magritte by Angela Wenzel, from the *Adventures in Art* series, Prestel, 1998

Salvador Dali by Mike Venezia, from the *Getting to Know the World's Greatest Artists and Composers* series, Watts, 1994

The Essential Salvador Dali by Robert Glogg, HH Abrams, 1998

INDEX